MARGARET MORGAN
and
MARY MORGAN PEDLOW

Memorial

RIVERSIDE PUBLIC LIBRARY

Labyrinths

Can you escape from
the 26 letters of the alphabet?

for Isabelle,
Gaspard & Gilles

with thanks to:

A FIREFLY BOOK

Published by Firefly Books Ltd., 2002

Copyright by Editions Nathan/HER, Paris — France, 2000, for the first edition
Copyright by Editions Nathan/VUEF, Paris — France, 2002, for the present edition
Original edition: *Labyrinthes*

First Printing

National Library of Canada Cataloguing in Publication Data

Mignon, Philippe
 Labyrinths

Translation of: Labyrinthes.
ISBN 1-55297-559-2 (bound).—ISBN 1-55297-579-7 (pbk.)

 I. Title.

PZ7.M583La 2002 j843'.914 C2002-900213-3

Publisher Cataloging-in-Publication Data (U.S.)

Mignon, Philippe.
 Labyrinths / Philippe Mignon. – 1st ed.
[64] p. : col. ill. ; cm.
Summary : An illustrated alphabetical adventure through 26 labyrinths.
ISBN 1-55297-559-2
ISBN 1-55297-579-7 (pbk.)
1. Maze puzzles. 2. Puzzles. 3. Alphabet. I. Title.
793.738 21 CIP GV1507.M54 2002

Published in Canada in 2002 by
Firefly Books Ltd.
3680 Victoria Park Avenue
Willowdale, Ontario M2H 3K1

Published in the United States in 2002 by
Firefly Books (U.S.) Inc.
P.O. Box 1338, Ellicott Station
Buffalo, New York 14205

Illustrations by Philippe Mignon
Text, unless otherwise noted, by Philippe Mignon
English translation by David Homel

Printed in Canada

Labyrinths

Can you escape from the 26 letters of the alphabet?

Maybe...
but first you'll have to find your way in!

PHILIPPE MIGNON

FIREFLY BOOKS

ALLIGATOR

Lurking among

the mangroves,

the golden-eyed

alligator is sleeping.

But is he really

sleeping?

His nostrils flair

as the boat draws

near, slipping

over silent waters,

into his sights...

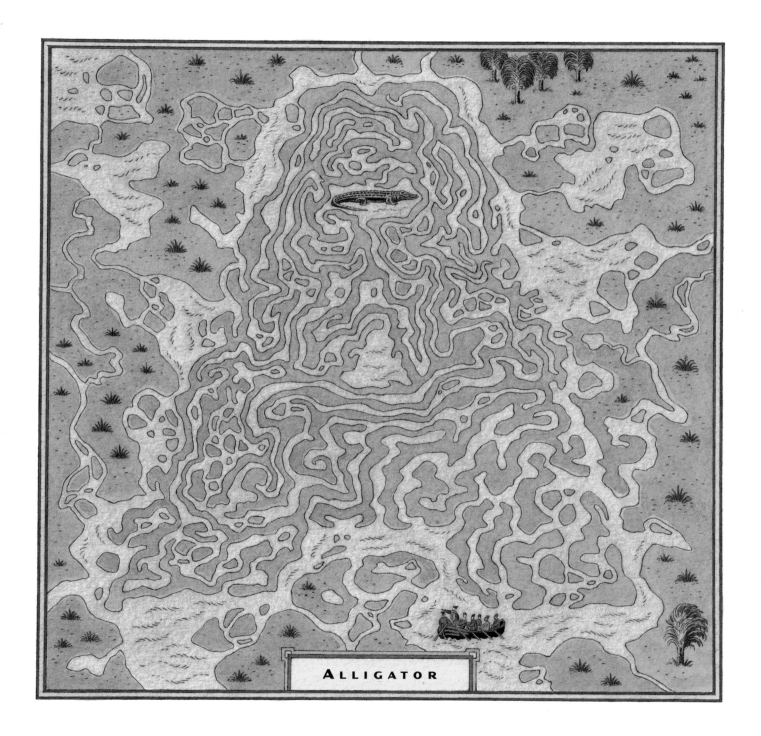

ALLIGATOR

Basilisk

From his perch

upon an ancient

wall of stone,

the basilisk keeps

watch, silent

and proud.

With a single

glance, he can

strike down

anyone who

might offend him.

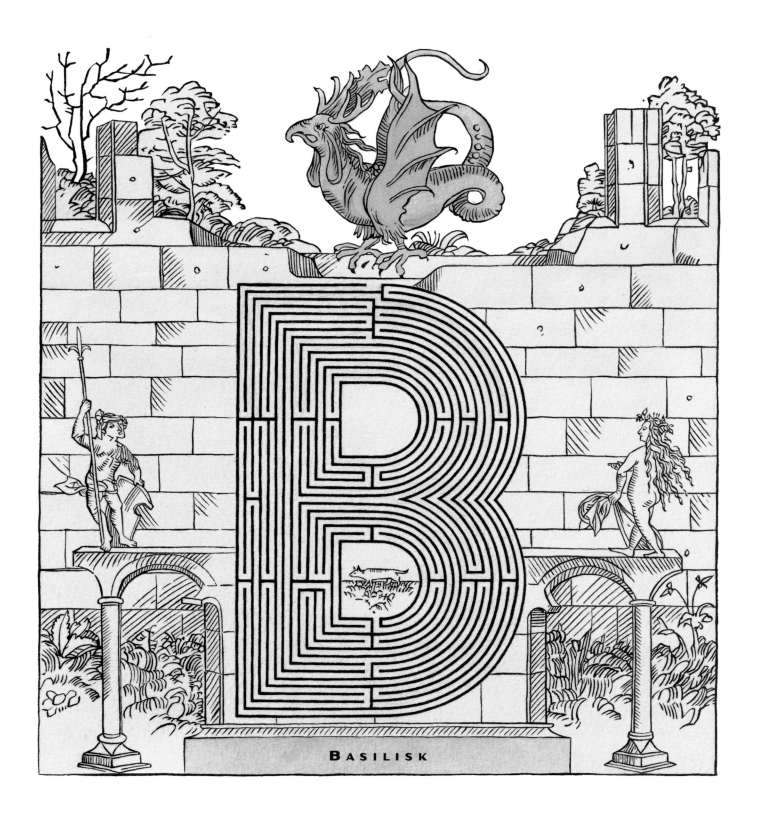

BASILISK

CHINA

Among the silent

pavilions, set off

by pools and

shady walkways,

a Chinese pagoda

stands on its own.

Solitary dreamers

and lovers alike

tell it their secrets.

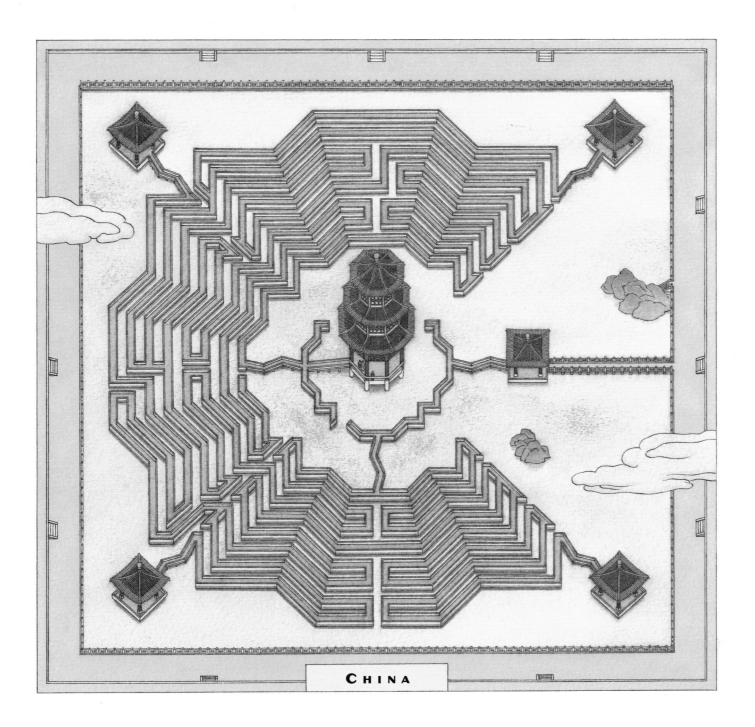

CHINA

DRAGON

The dragon stood tall,

its narrow eyes

and sharp ears

focused intently

on the far

distant mountains.

He hadn't

been wrong.

Someone,

or something,

was moving

ever closer to his lair.

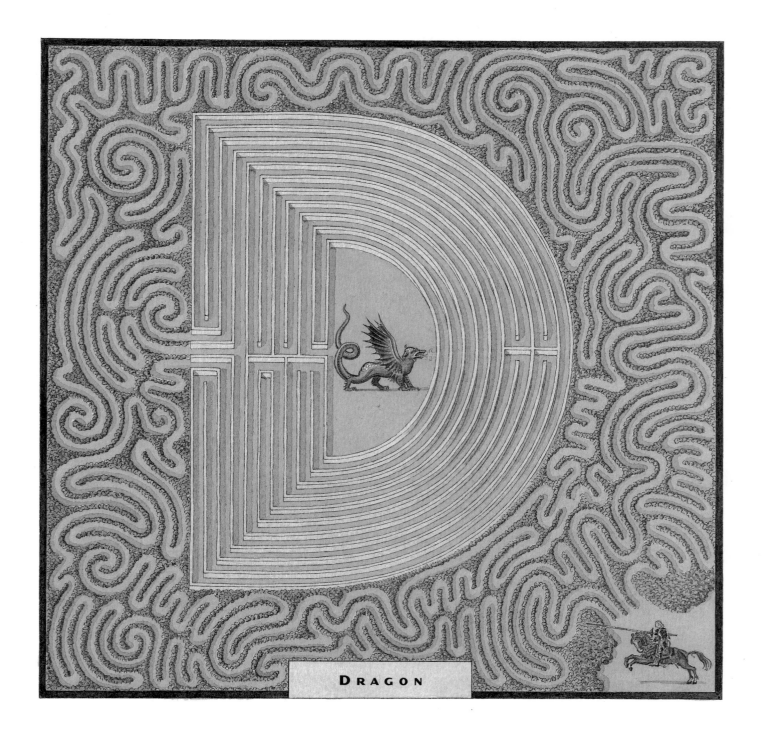

DRAGON

11

Elephant

In far-off India,

long, long ago,

Indra, king of the

gods, was never

seen without his

elephant. Every

day, he would ride

upon its back, and

his faithful friend

would whisper to

him the secrets of

the heavens.

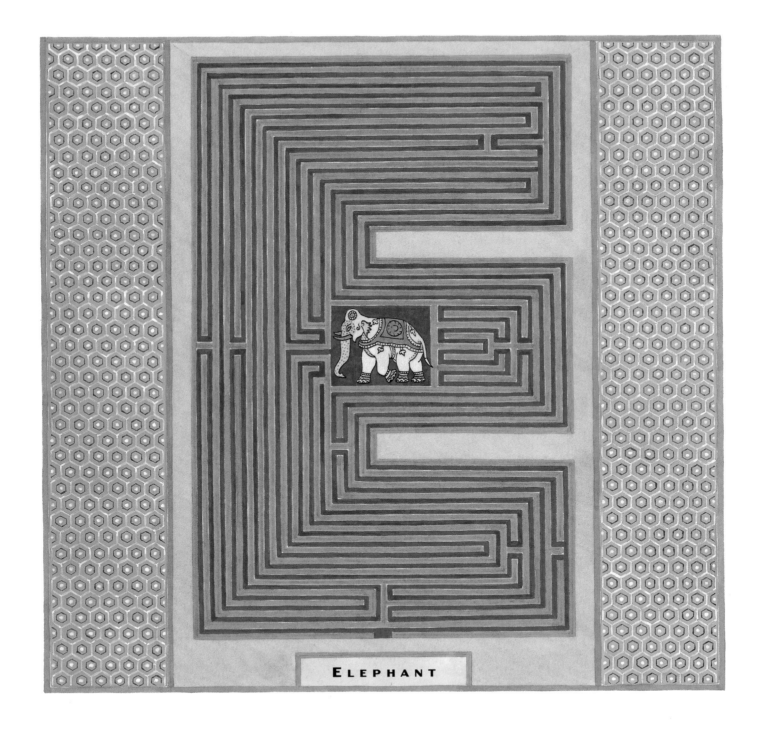

ELEPHANT

Flamingo

I should like to

rise and go...

Where the

knotty crocodile

Lies and blinks

in the Nile,

And the red

flamingo flies

Hunting fish

before his eyes...

Flamingo: from "Travel," in *A Child's Garden of Verses*,
Robert Louis Stevenson.

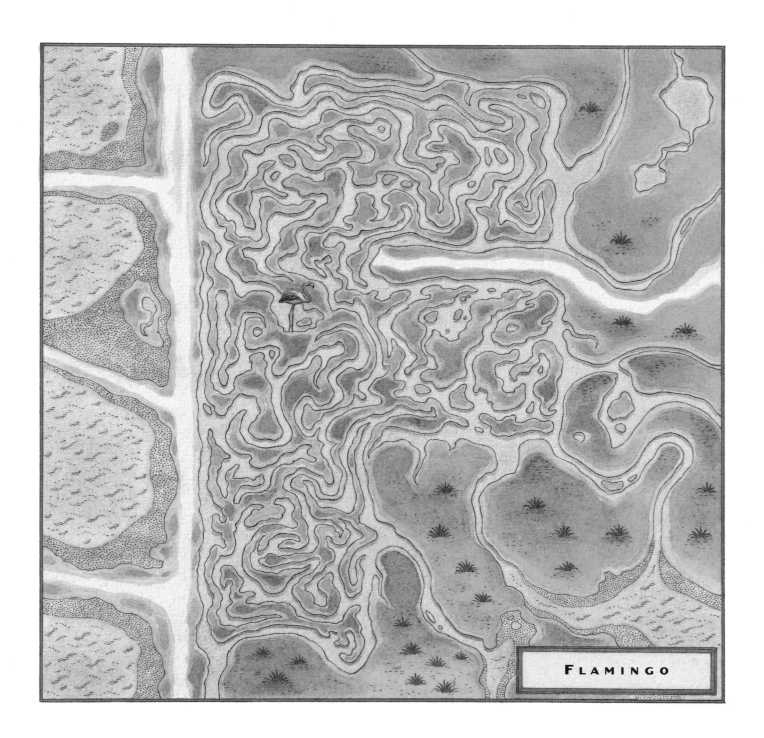

FLAMINGO

Gondola

The canal and

the gondola

are as one;

one completes

the other.

Without

gondolas, there

would simply

be no Venice...

Gondola: based on Théophile Gautier,
Voyage en Italie.

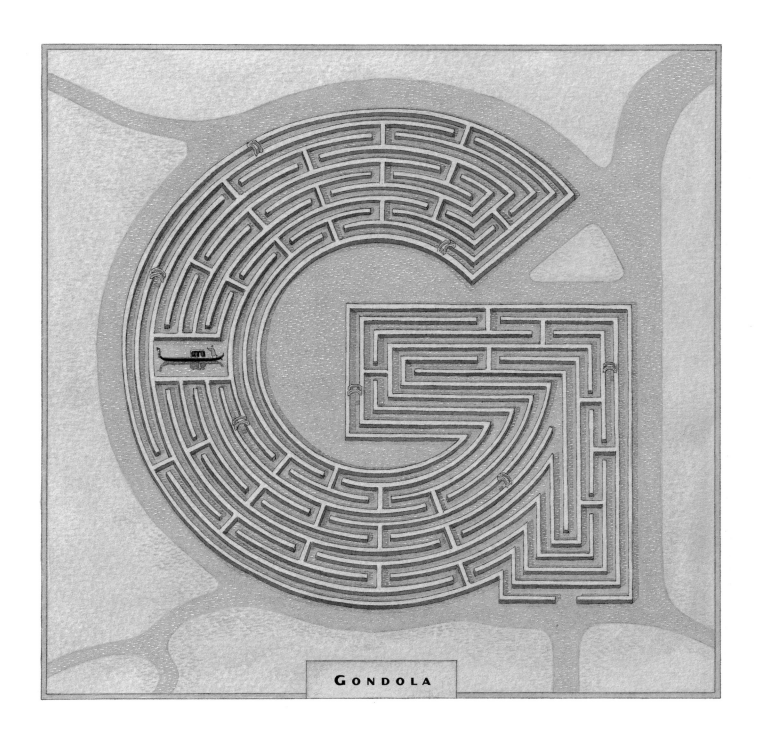

GONDOLA

17

Hotel

Once inside the city,

the tired traveler

searches for lodgings.

But where can he go?

All around, winding,

twisting streets lead

back to the beginning.

Will he find an inn for

the night? A hotel? A

roof over his head?

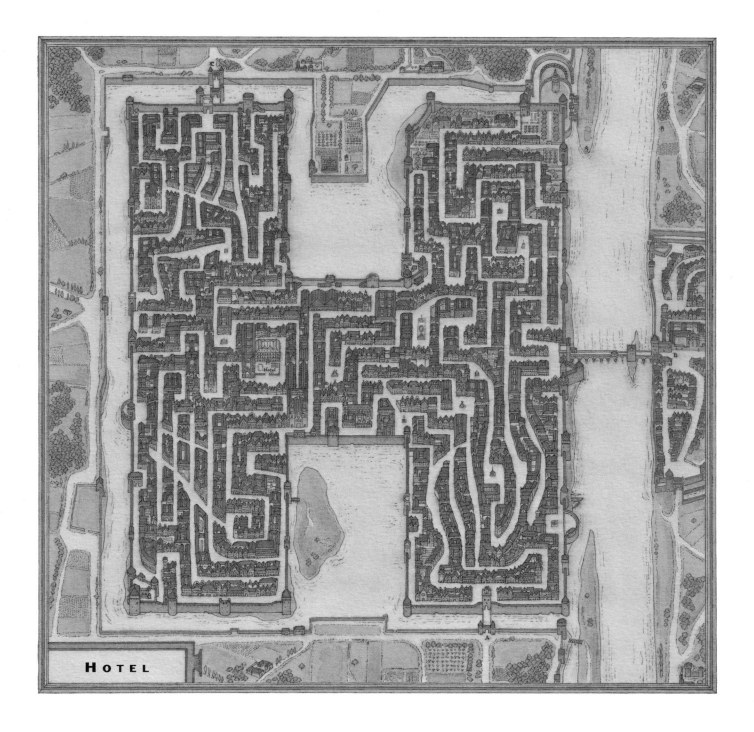

HOTEL

ISLAND

The island rises

from the water,

wind-swept,

its shores lashed

by waves.

It is a world

of mystery

unto itself.

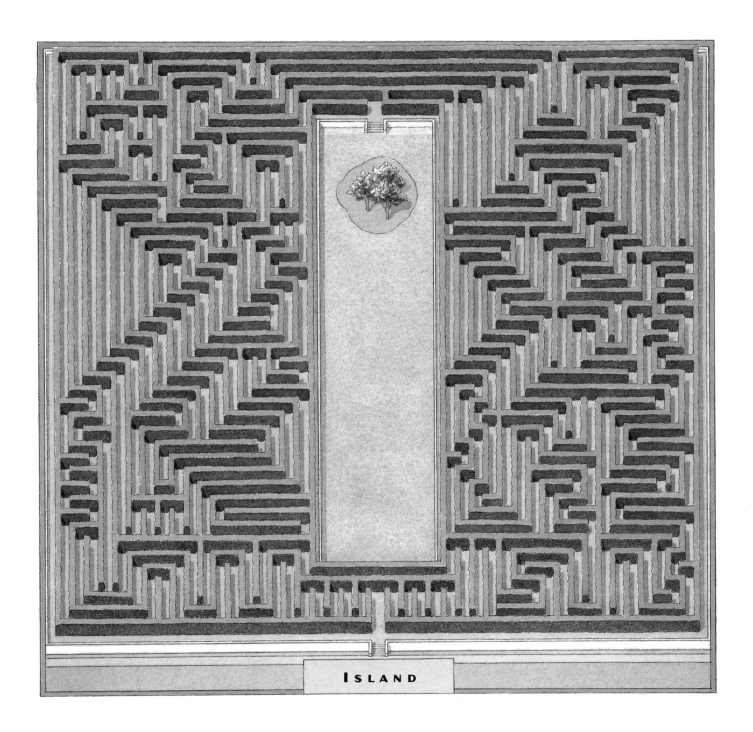

ISLAND

Jockey

The hunter returns

from the forest,

the fisherman from

the river, the farmer

from the field,

the housewife

from the market,

the boatman from

the far shore.

And the jockey

from the racetrack.

Jockey: based on Raymond Queneau,
Morale élémentaire.

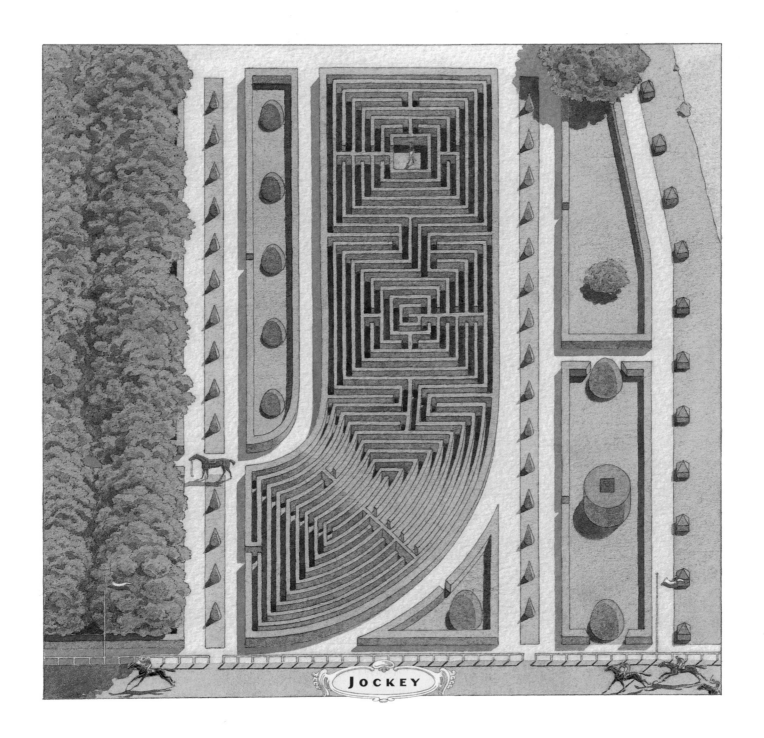

JOCKEY

Kayak

The Inuit built

their igloo at the

mouth of the river.

From there, they

could easily

reach the ocean,

where they would

hunt for seal,

or head into the

highlands in

search of caribou.

Kayak: based on Maurice Métayer,
Contes de mon iglou.

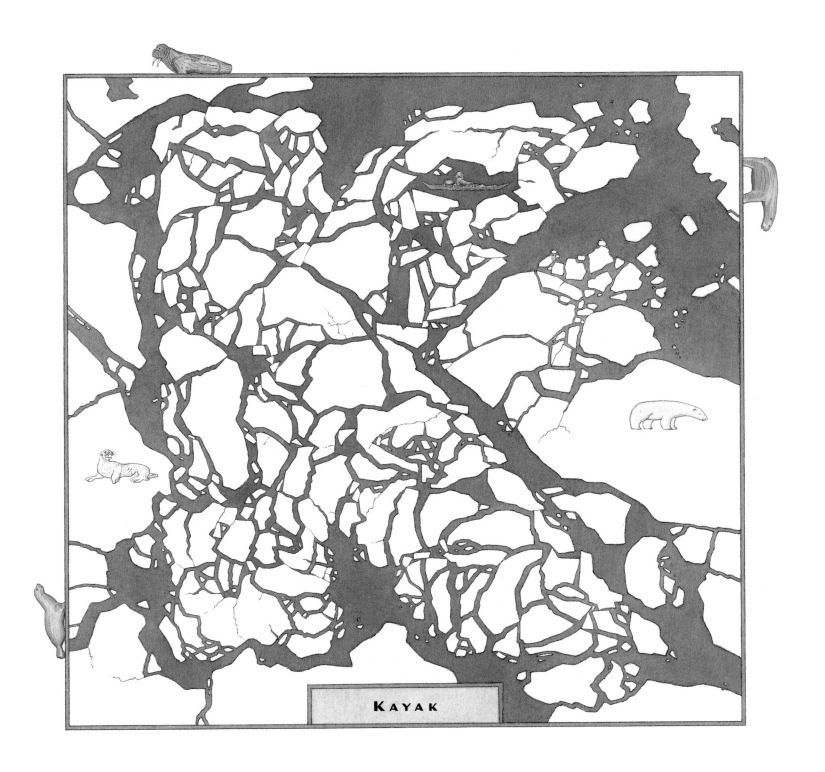

KAYAK

Lion

In the shadows, his

head turned in my

direction, a lion was

lying on its side.

It had all the terrible

strength of its race,

clothed in its superb

coat. Its long mane

flowed down upon

its shoulders, nearly

to the ground.

Lion: based on Joseph Kessel, *Le lion*.

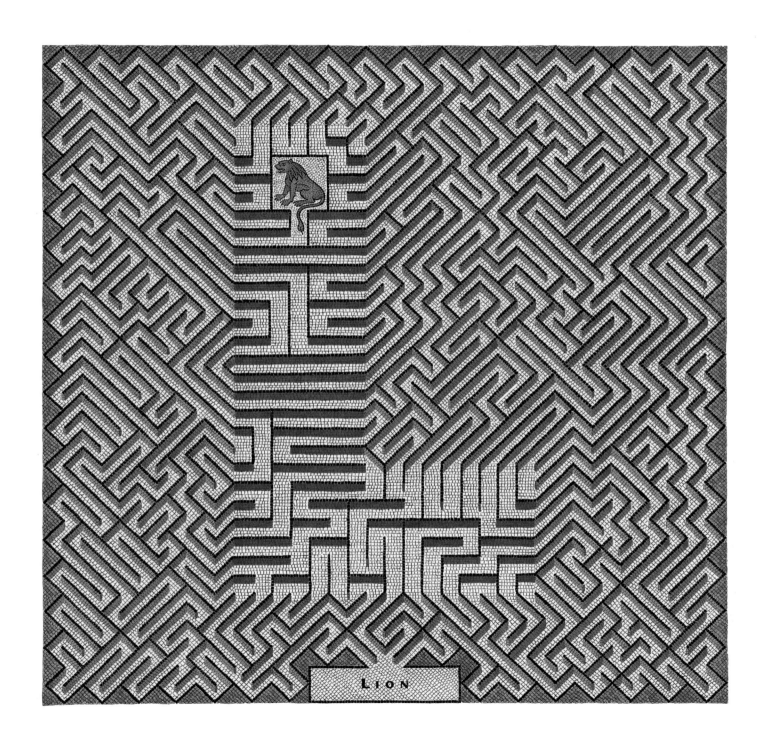

LION

Minotaur

The Minotaur

has grown old,

far from his

homeland.

One day he

will return to

see the sphinx

and the unicorn,

who will tell

him that it is

growing late for

mythical beasts.

Minotaur, based on Robert Desnos, *Minotaure*.

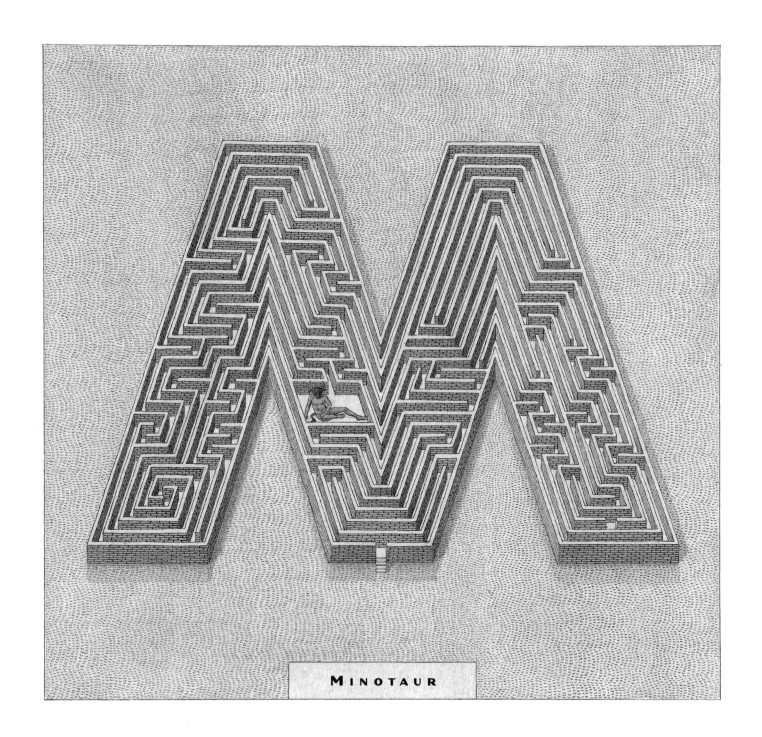

MINOTAUR

Narwhale

The Narwhale,

rising to the surface

of the Polar Sea,

and finding it

sheeted with ice,

thrusts his horn up,

and so breaks through.

Narwhale: Herman Melville, *Moby-Dick*.

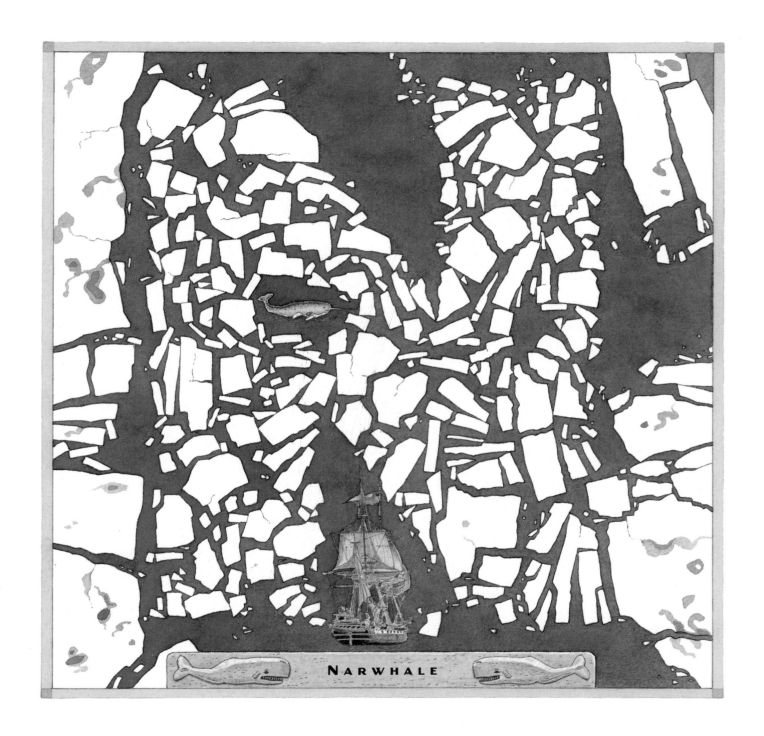

NARWHALE

Obelisk

At the end of

deserted streets,

above the balconies,

a skyline of obelisks

rose into the air,

incandescent with

pure heat, scalloped

with the summits

of towers, and the

copings of palaces

and temples...

Obelisk: based on Théophile Gautier,
Le roman de la momie.

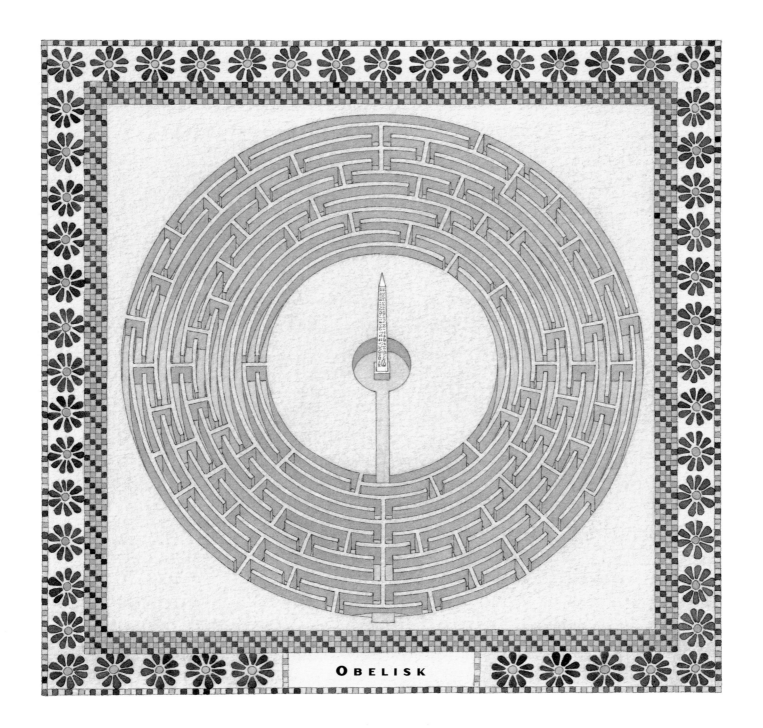

OBELISK

33

Pirate

Where shall we

adventure, to-day

that we're afloat,

Wary of the

weather and

steering by a star?

Shall it be to

Africa, a-steering

of the boat,

To Providence,

or Babylon, or

off to Malabar?

Pirate: from "Pirate Story," in *A Child's Garden of Verses*,
Robert Louis Stevenson.

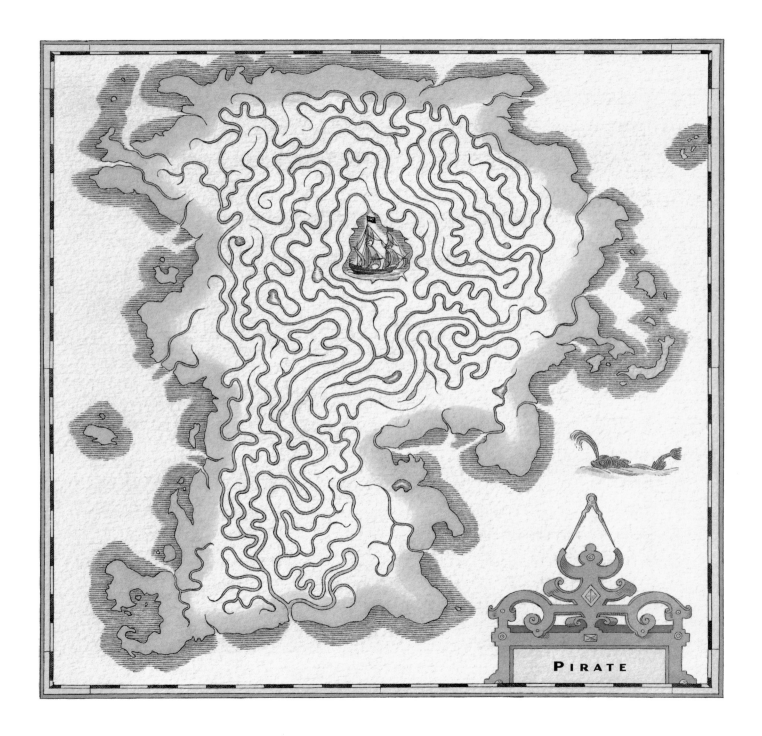

PIRATE

Quetzal

The quetzal,

with its

dazzling

plumage,

inspired the

great god

Quetzalcoatl,

who fashioned

a world of

wonders with

his two hands...

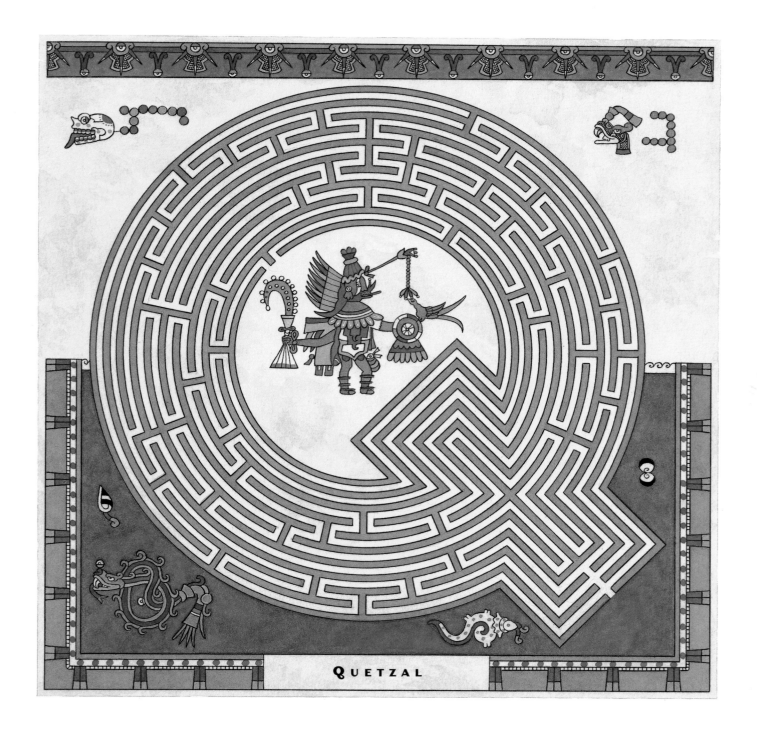

QUETZAL

RHINOCEROS

On the savannahs,

on the veld,

on the open

grasslands,

the single horn

and leather skin

of the rhinoceros

keep away both

friend and foe.

Rhinoceros, based on Claude Roy,
Le rhinocéros.

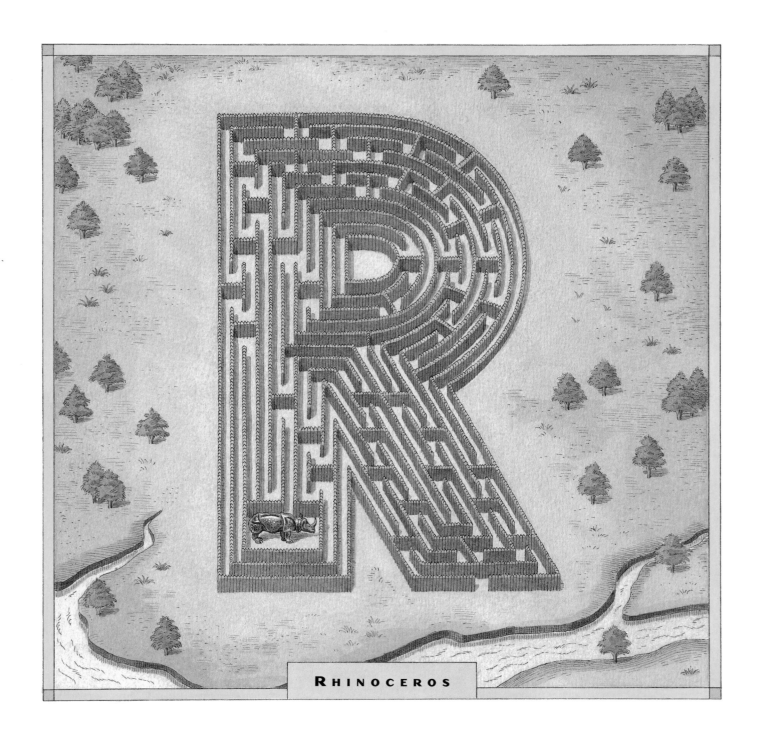

RHINOCEROS

SNAKE

Here and there

I saw snakes,

and one raised

his head from

a ledge of

rock and

hissed at me

with a noise

not unlike

the spinning

of a top.

Snake: Robert Louis Stevenson, *Treasure Island*.

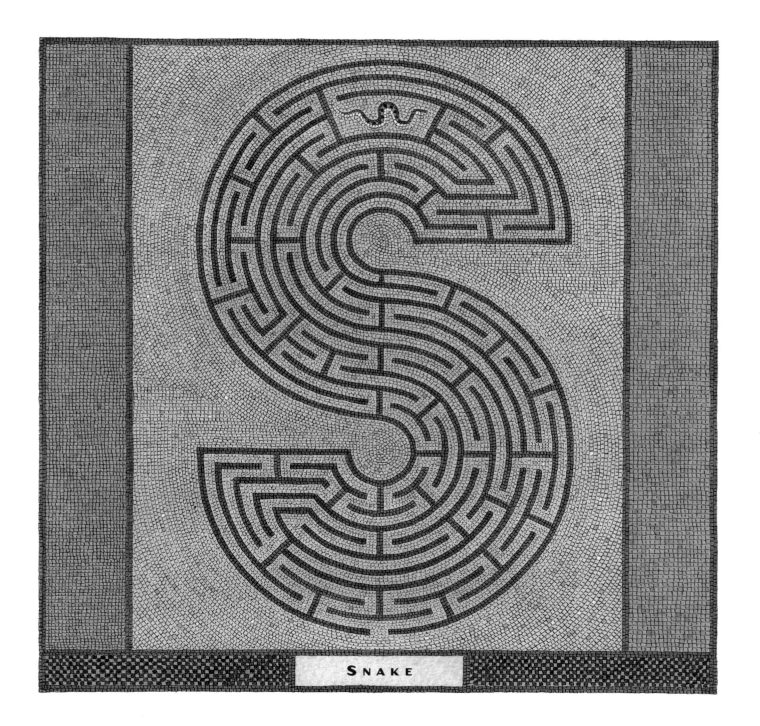

SNAKE

Tower

What prisoners are

locked up in the

tall tower that

keeps watch over

sea and land,

defying the storms?

And what were

their crimes — are

they innocent or

not? Who knows

the answer?

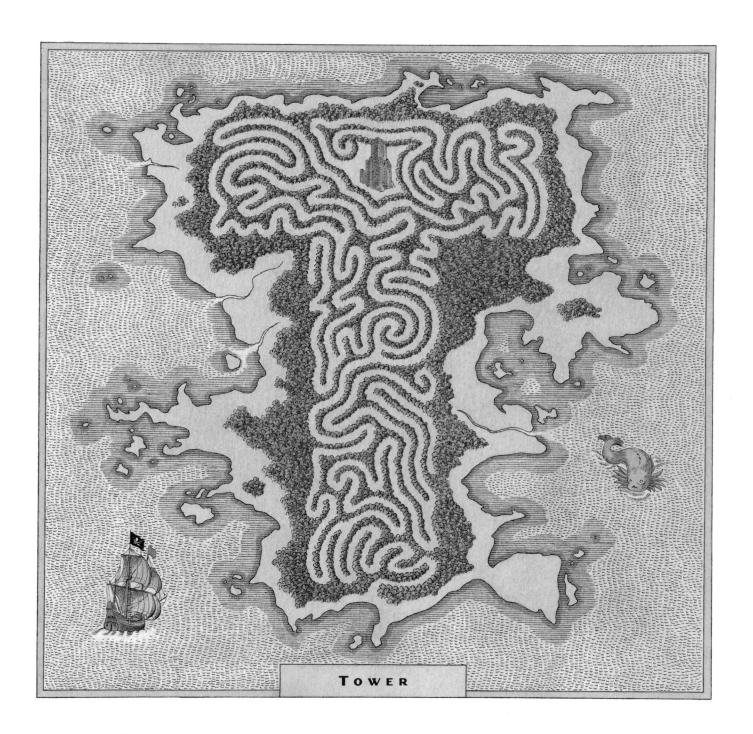

TOWER

Ulysses

When dawn

showed her rosy

fingers through

the mists,

Ulysses put on

tunic and cloak,

and the nymph

a silvery wrap...

Then she began

to help Ulysses

in his work.

Ulysses: Homer, *The Odyssey*,
based on the translation by W. H. D. Rouse.

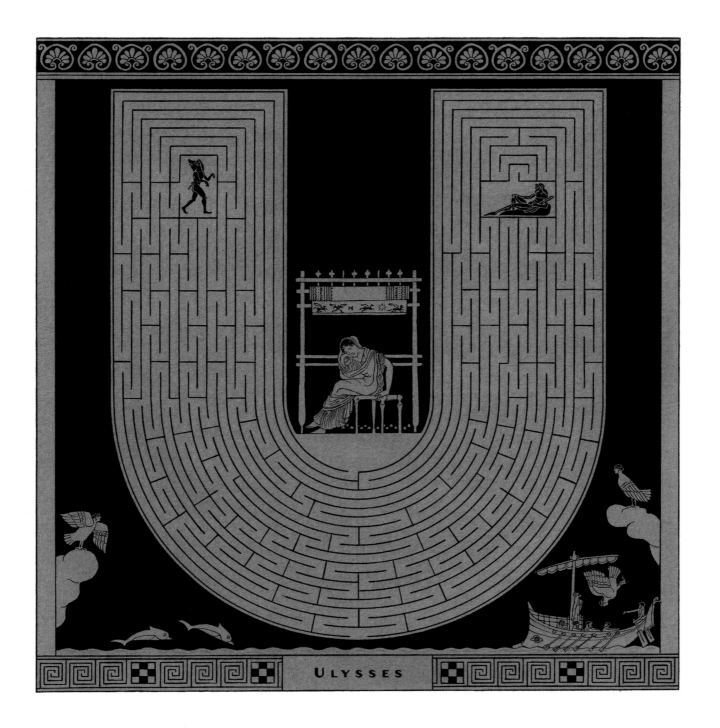

ULYSSES

Volcano

If they are well

cleaned out,

volcanoes

burn slowly

and steadily,

without any

eruptions.

Volcanic

eruptions are

like fires in

the chimney.

Volcano: Antoine de Saint-Exupéry, *The Little Prince*,
translation by Katherine Woods.

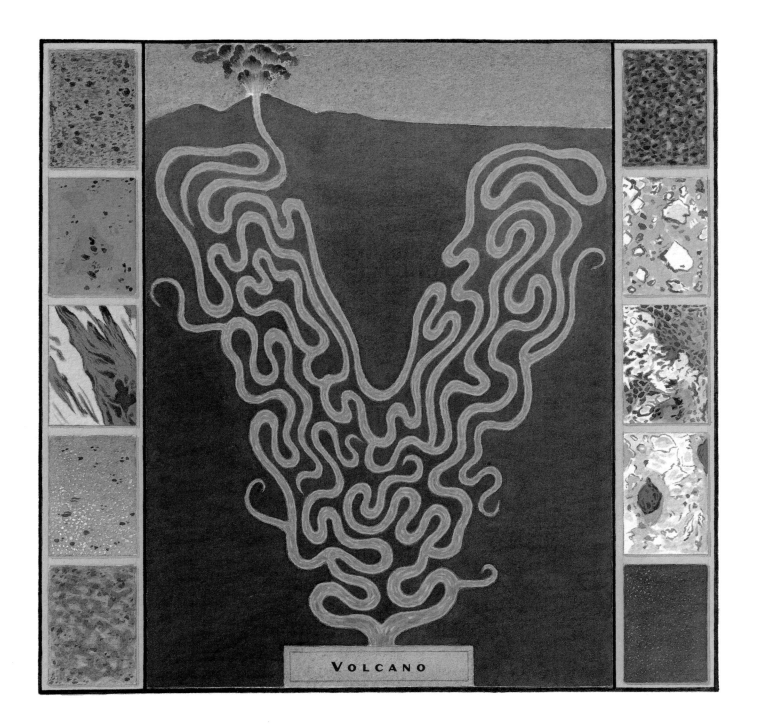

VOLCANO

Wapiti

A lonely northern

wanderer, a wapiti

stands on a frozen

lake, nose in the

air, sniffing for

the warmth of the

herd. Where have

they gone? Can

you help bring

him home?

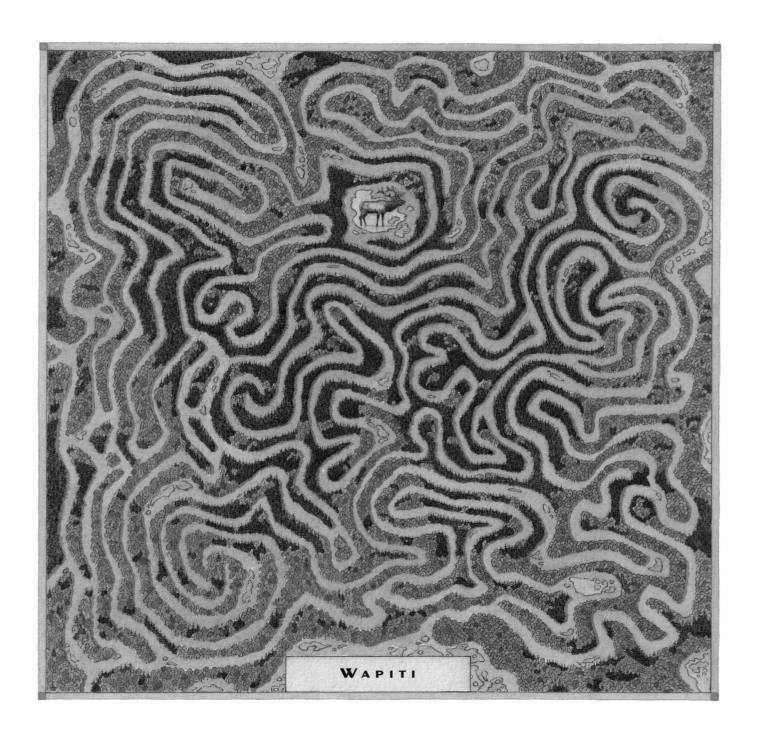

WAPITI

Xerus

Crouching in the

heart of the

thicket, the

earth-colored

xerus hides.

Above him, the

hawk circles.

Both play the

waiting game...

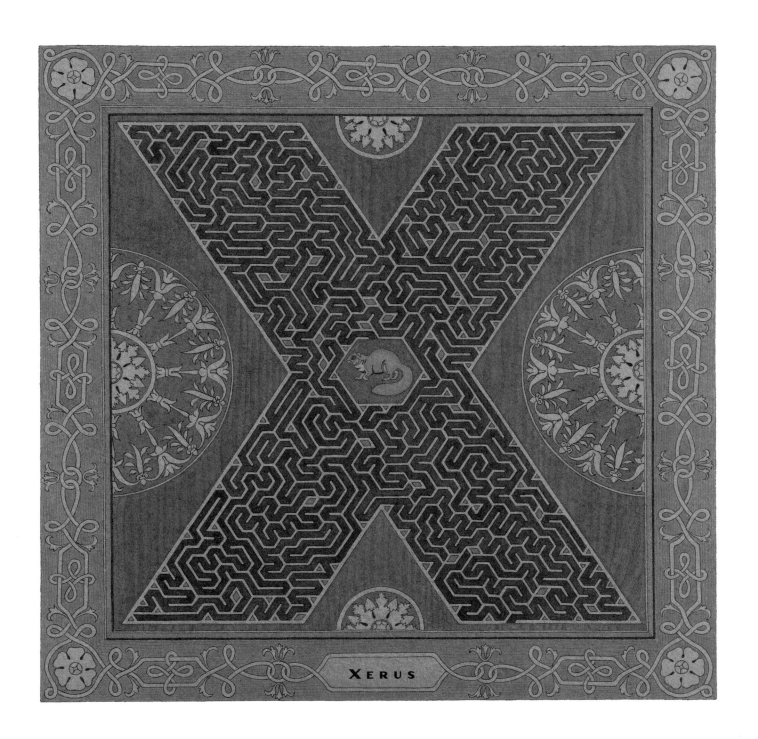

XERUS

Yak

The Sherpas of

the Himalayas

worship the yak.

His fur is as soft

and silky as the

coat of snow that

lies upon the roofs

of the mountain

villages and keeps

them warm.

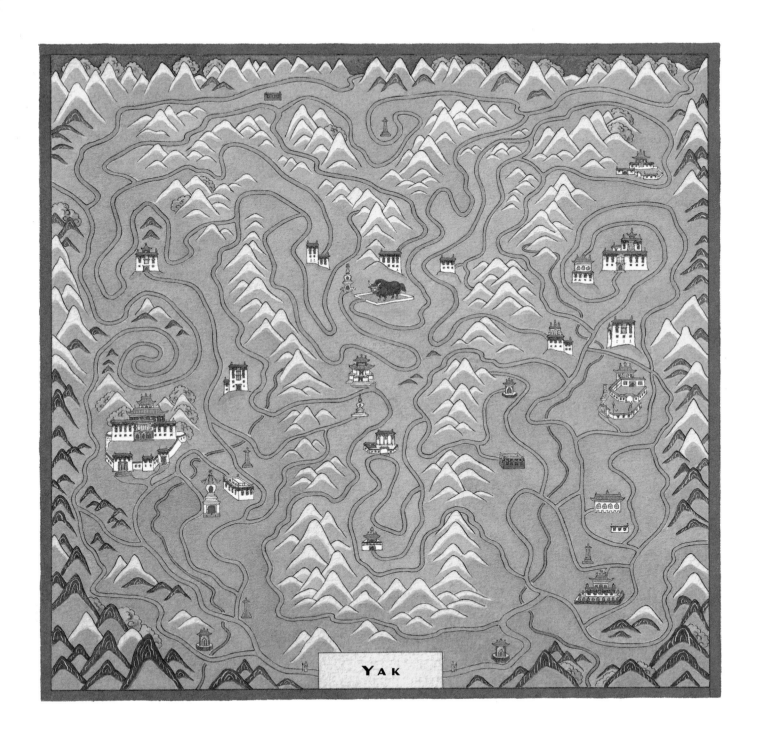

YAK

Zıggurat

On the desert

plain, the

people built

a ziggurat,

a mountain

that would

reach from the

earth to the

sky. But no

tower can go

that high!

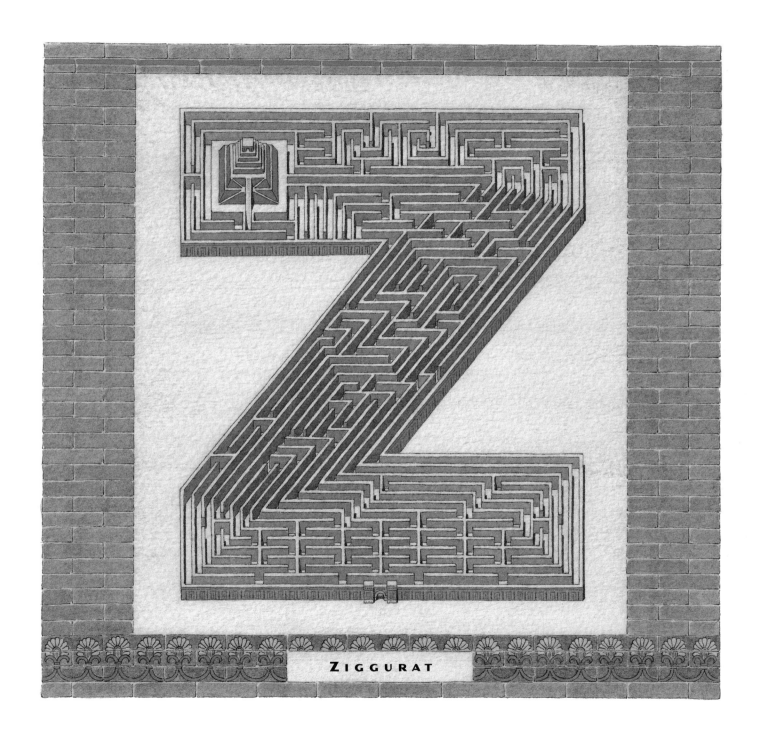

ZIGGURAT

Solutions:
The Way In and the Way Out

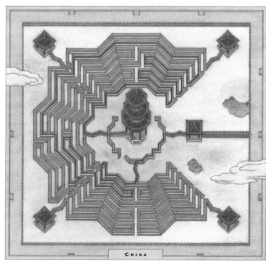

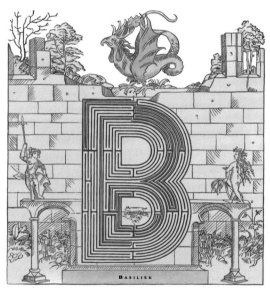

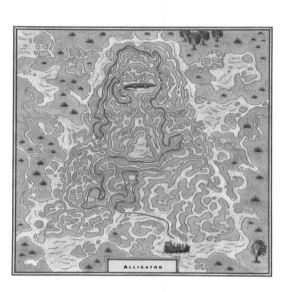

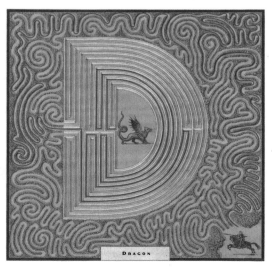

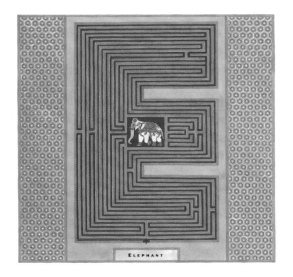

ELEPHANT

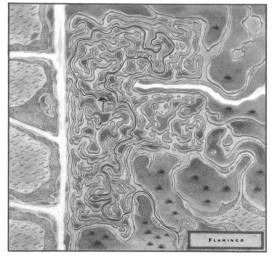

FLAMINGO

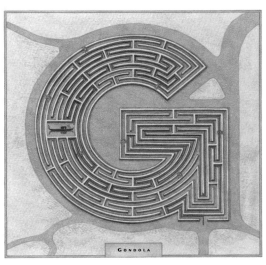

GONDOLA

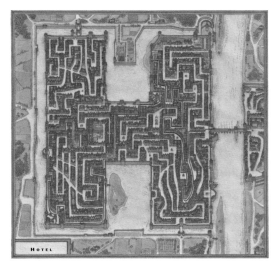

HOTEL

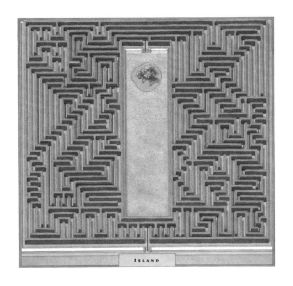

ISLAND

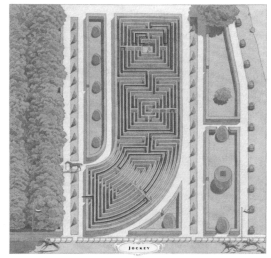

JOCKEY

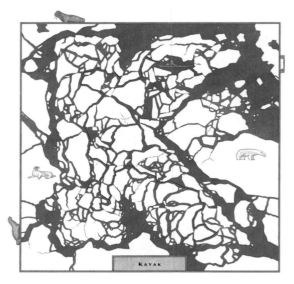

KAYAK

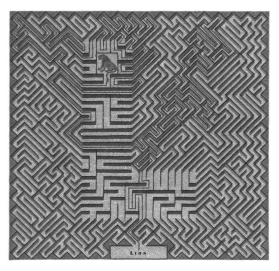

LION

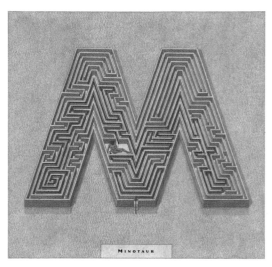

MINOTAUR

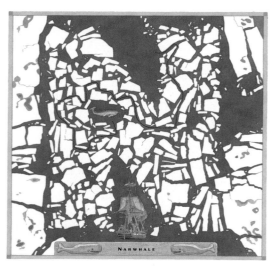

NARWHALE

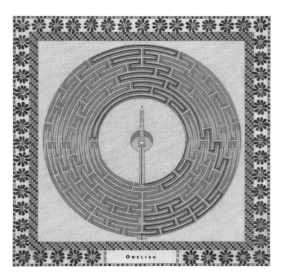

OBELISK

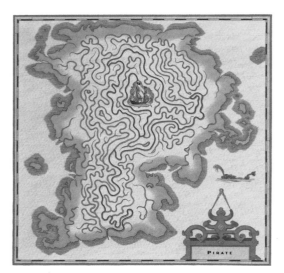

PIRATE

58

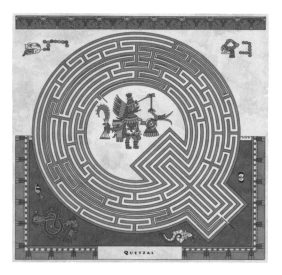

Quetzal

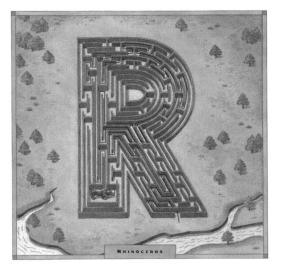

Rhinoceros

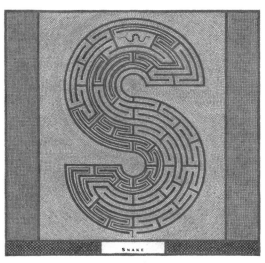

Snake

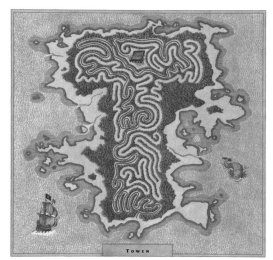

Tower

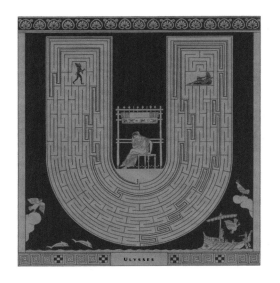

Ulysses

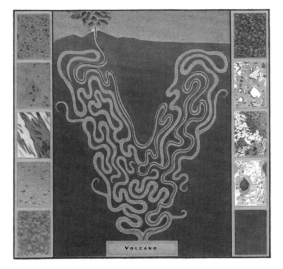

Volcano

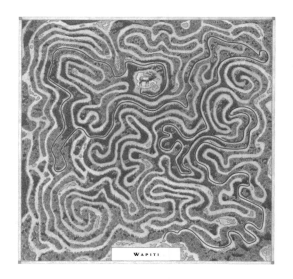

WAPITI

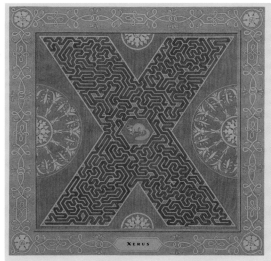

XERUS

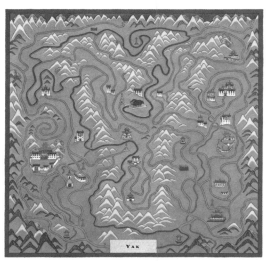

YAK

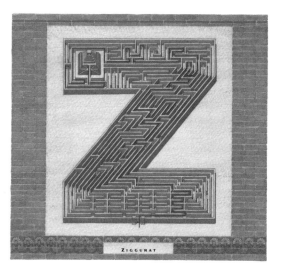

ZIGGURAT